Draw Portraits

BENEDICT RUBBRA

Series editors: David and Brenda Herbert

A & C Black • London

First published in 1980
New style of paperback binding 1995
By A&C Black Publishers Limited
36 Soho Square, London W1D 3QY
www.acblack.com

Reprinted 1998, 2000, 2002, 2007, 2008

ISBN: 978-0-7136-8302-8

Cover design by Emily Bornoff

Printed in China by WKT Company Limited

This book is produced using paper that is made from wood grown in managed, sustainable forests. It is natural, renewable and recyclable. The logging and manufacturing processes conform to the environmental regulations of the country of origin.

Contents

Making a start

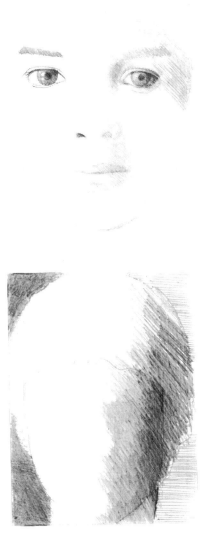

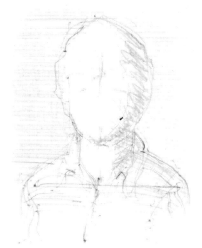

To draw portraits successfully you must learn to select important shapes and lines, to see and understand a complete form and to make your pencil describe what you see. (This book is primarily concerned with pencil drawing—most of the examples were done with a 2B pencil.)

You cannot draw a form unless you understand it. For example, these three simple shapes can be drawn without difficulty

—but a more complex form such as this

is more difficult because it is less easy to understand. The shapes and forms must first be analysed.

The first thing to do, therefore, when you start to draw a portrait is to discover the lines and shapes that you can clearly understand.

The head is a three-dimensional object made up of rounded forms and different planes or surfaces. The contour, or outline, that you see is not the edge of a flat shape but the point at which the form turns away from you and disappears from view.

Don't make the common mistake of thinking that you will achieve a likeness just by getting the eyes, nose and mouth right. It is the varying shapes between the features, the total shape of the head, the quality and texture of hair and skin, that make one person distinct from another.

Select those things that *you* feel are relevant. A portrait must convey your idea of the person. It is what you choose to put in and what to leave out that will bring the portrait to life.

Look at the portrait opposite. Note the pose, the relationship of the set of the head to the shoulders. The three sketches on the left will help you understand the form and character of the subject.

1. This shows the upright position of head and shoulders and the simplified contour of the cheek and jaw in contrast to the soft shading within the face. The solid character of the subject is emphasized by even line and tone.

2. Uneven emphasis of line can change the quality of form.

3. A reminder of the characteristically solid form of the head.

4

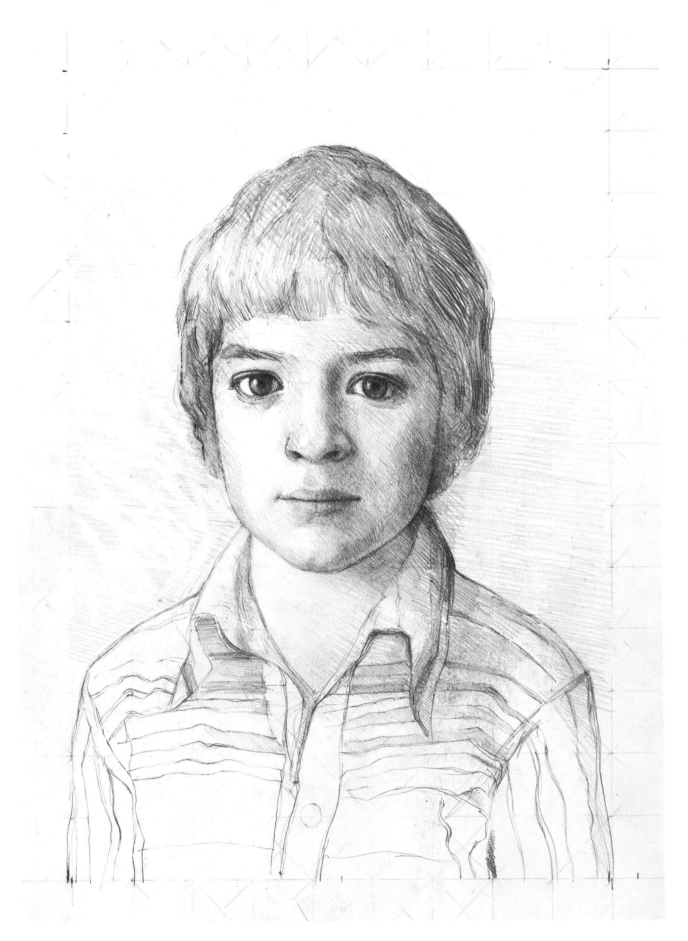

Proportion

There are certain basic proportions. If you know these, you can watch for how and when they vary.

A frontal view can be divided by a grid (a). On an average head the distance from eye centre to eye centre is equal to the distance from the bridge of the nose to the mouth. The tip of the nose (where you see the highlight) falls half way between the bridge of the nose and the mouth; this distance will fit six times vertically and four times horizontally into the area of the head.

There is a fixed relationship between the centre of the cheek bone, the centre of the ear and the base of the skull. These three points form a straight line, and the ear is the half-way point (b). Note the relative position of the ear to the highest point of the head and how the profile is divided into six parts as in (a).

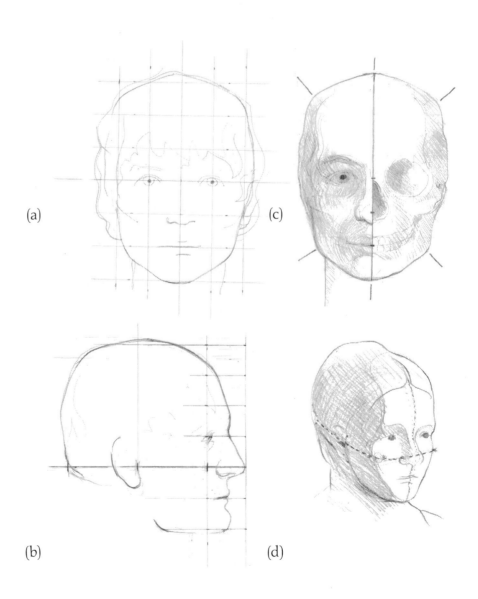

(a)

(c)

(b)

(d)

Notice where the main contours change direction and the relative positions of these changes; and how the forms of the forehead, cheek and jaw flow into each other. Make your eye travel across these forms. Try to understand the characteristic forms and shapes of the whole (c).

Visualise the two aspects, front and side, as one three-dimensional form (d). Notice how the outer contour of the cheek repeats itself on the inner side, where the tone changes. This contour indicates the forms of the face, and plays a very important part in portraiture.

Whatever the position of the head, the relationship between the cheek, the ear, and the base of the skull remains constant. Notice how the line linking these three points tilts as the head tilts, when looked at from the position marked 'eye level' on diagrams a and b. Then note the relative positions of the eyebrow to the ear when the head is tilted forward (a) and of the mouth to the ear when the head is tilted backwards (b).

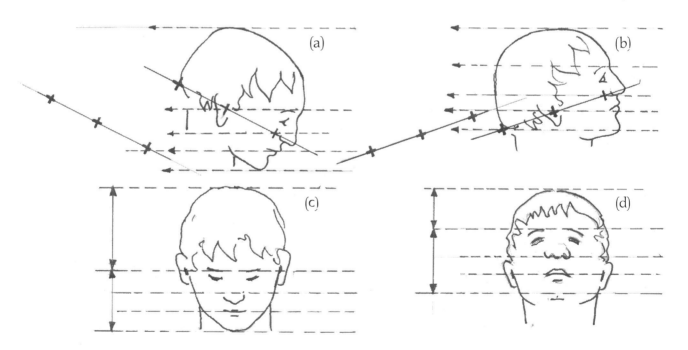

These positions will be the same when seen from the front (c and d), but because the head is tilted towards or away from you the horizontal proportions will be foreshortened—particularly the distance between the eye and the chin and between the eye and the top of the head.

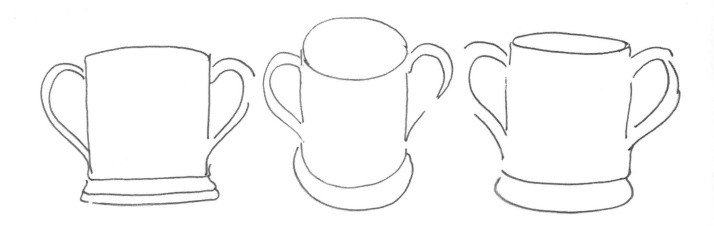

See how the simple shape of a cup changes according to its position—this will help you to understand how the head can change shape in the same way.

You must always be aware of the position of your eye in relation to the subject. Make a note, for example, of the exact position of the sitter's ear and eye and use this reference, if necessary, to re-adjust your own viewpoint accurately.

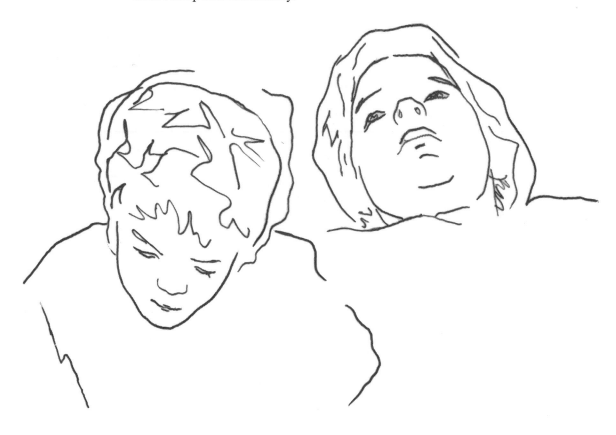

Using your pencil

Practise making your pencil describe what you have seen and understood.

(a) Vary the thickness of the line. Treat the form nearest to you (e.g. the chin) with a richer and thicker line. The part of the drawing that is emphasized will appear nearer because it is noticed first.

(b) Draw the nearest part in detail and treat the rest with a softer broken line. The quality of the line makes a three-dimensional form.

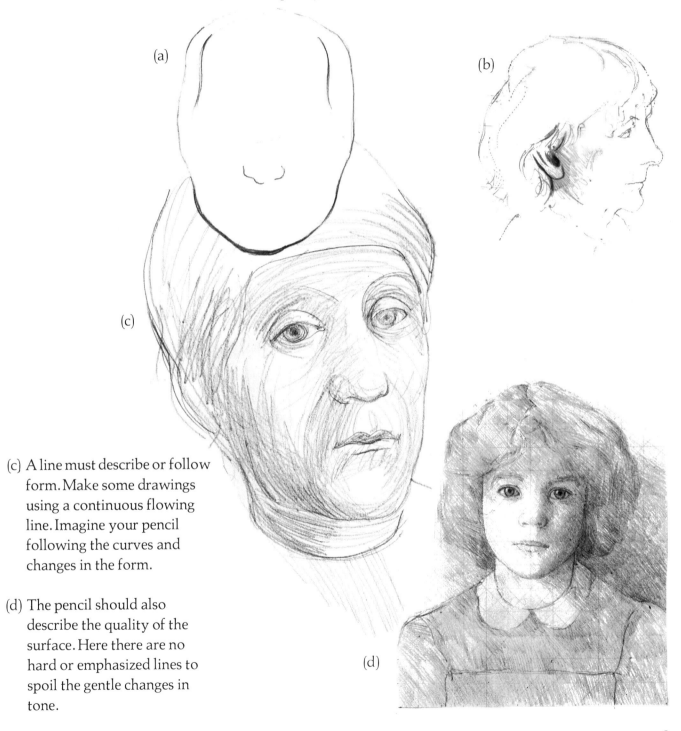

(a)

(b)

(c)

(c) A line must describe or follow form. Make some drawings using a continuous flowing line. Imagine your pencil following the curves and changes in the form.

(d) The pencil should also describe the quality of the surface. Here there are no hard or emphasized lines to spoil the gentle changes in tone.

(d)

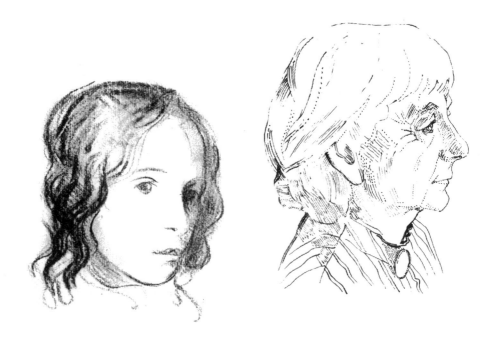

Look for different characteristics and vary the way you draw and the medium you use accordingly—charcoal for a simple statement about tone, pen and ink for a crinkled texture.

Experiment with your pencil. Try mixing pen and pencil. Use the side of the pencil as well as the point. Note the other variations of texture below—a kneaded eraser has been used to vary the tone.

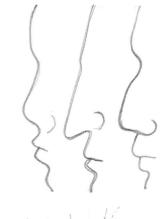

Study the profile to see the relative angles of forehead and nose and how much the nose dips in at the bridge, and also the curve from the underside of the nose to the upper lip.

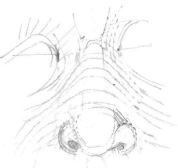

Notice particularly the different planes and the characteristic way the form flows into the cheek and round the eye socket (left).

One of the most characteristic features of the nose is the way the forms move down from the forehead and into the eye socket. Notice how these forms have been 'felt' with the pencil, below.

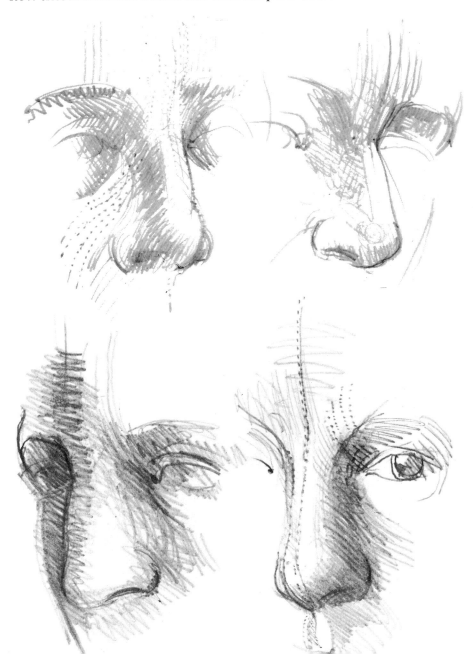

Placing yourself and your sitter

Place your easel as near as possible to your subject so that you can look from drawing to subject without much head movement. There should be plenty of space between you and the easel. If you are left-handed, have the paper or easel to the left of the sitter, otherwise your drawing arm will block your view.

Your sitter will find it easier to keep still if he or she has a comfortable chair with a straight back.

Keep the background simple—if necessary place a piece of plain card behind the sitter.

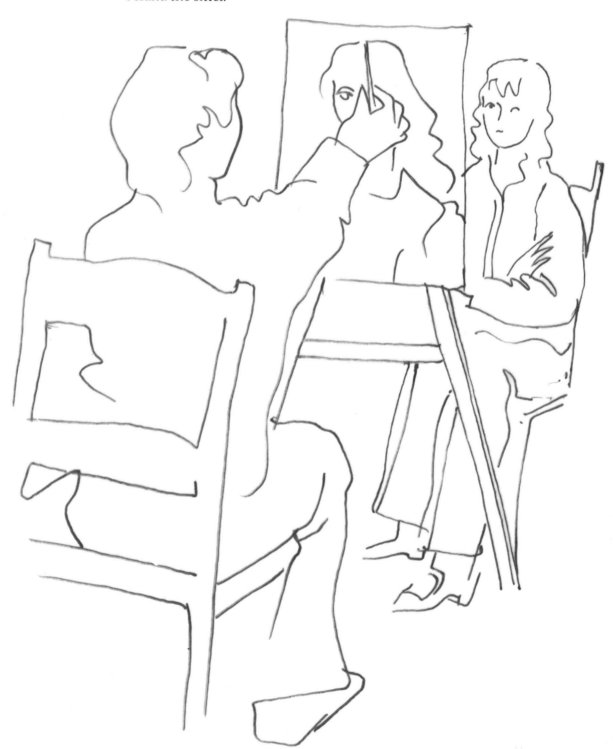

Decide on your eye level. Is it to be above or below the level of the centre of the sitter's face? Ask yourself whether looking slightly up at or slightly down on the sitter would make a more characterful drawing. If you look down on the head the shape of the face becomes elongated, even though the proportions are foreshortened.

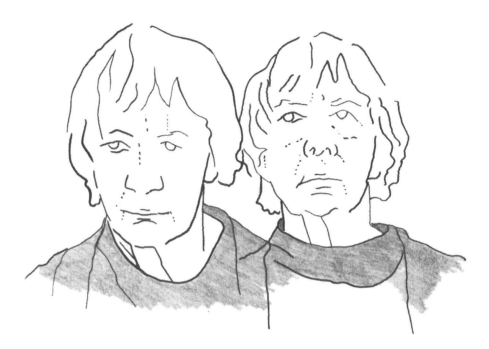

It is worth spending time adjusting your position in relation to the sitter before you start drawing. Note the position of ear and nose and how much of the nostril is in view. Fix the point where the contour of the shoulder joins the chin or neck. (This is easier if the sitter wears something with a simple neckline.) Notice how this point varies on the two positions illustrated here.

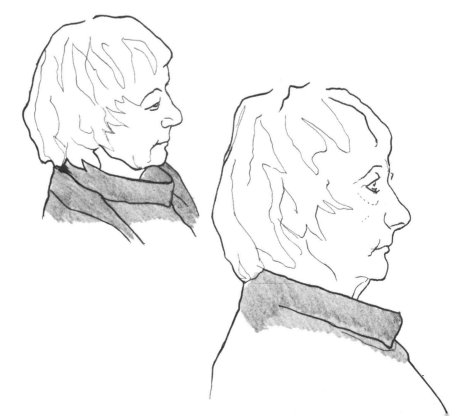

Looking for the complete shape

Once you have become reasonably familiar with your pencil you will be able to decide how to use it according to the person you are drawing.

Look for the characteristic shape of the head. Here are three views of the same head. A simple line describes the contour.

If the contour is toned in, the head can be seen as a solid shape. The line has lost its importance and the tone makes the shape. Note also the shapes left by the white paper.

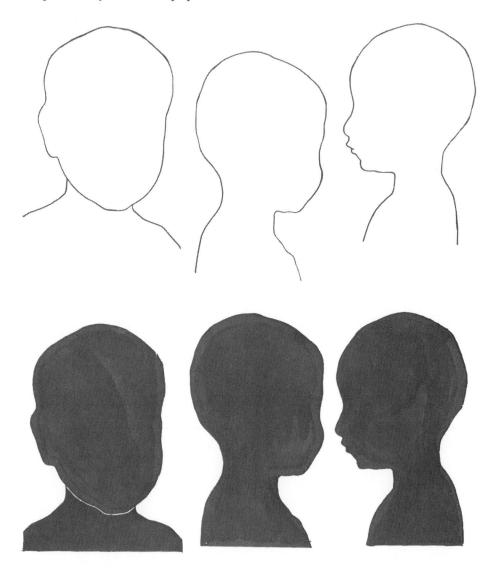

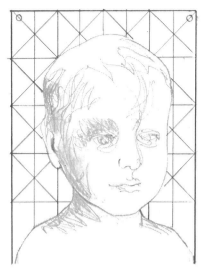

Pin a piece of paper behind the subject, large enough to cover the area of the head, with a network of diagonal and vertical lines drawn on it. Divide your drawing paper in the same way before you start drawing. Place yourself so that you can see a vertical line touching a point on the head and always refer back to this position. Now start drawing the contour, noting the points at which the diagonal and vertical lines meet the head.

Try placing the subject in front of a window and concentrate on the dark shape or silhouette. Now try and describe the shape by looking for the points where the contour changes direction, and make a series of drawings using only straight lines based on these changes of direction.

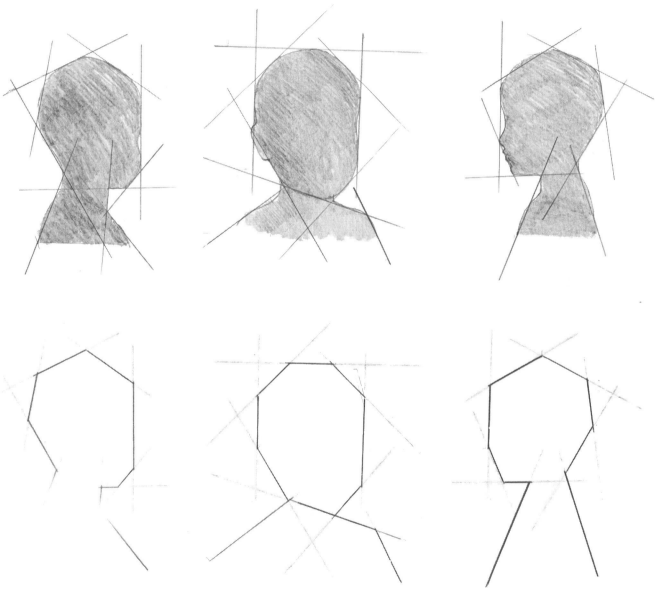

Light

Use the direction of light to emphasize the characteristic forms of the head.

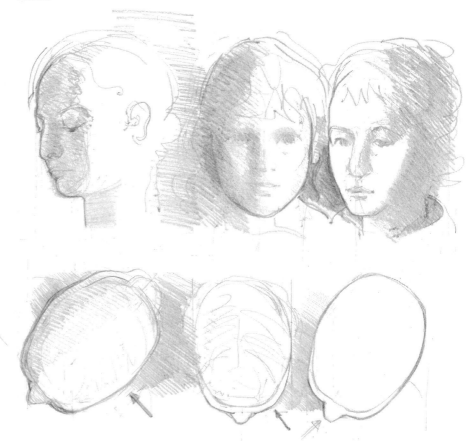

These three drawings show how light from different directions (indicated by the arrow on the same heads seen from above) can reveal different aspects of the head. All the surface forms away from the light should be first toned in without drawing anything in detail. Remember that a sudden change of tone will indicate a sudden change of direction in the form and a gradual change of tone will convey a smooth or gradual change of direction (below).

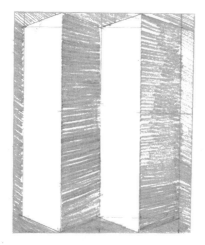

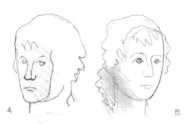

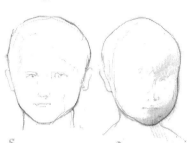

A characteristically square head with light from the side (top, left).

A soft front light for a gentle, oval face (top, right).

A bland, even light for a wide open face (bottom, left).

Light directed from above to emphasize the fullness of a child's cheeks (bottom, right).

Never have too strong a light on your sitter or the forms will become confused by shadows. If possible, use a constant north light. The problem of changing sunlight falling on the subject can be solved by hanging a white sheet over the window. This will diffuse the light without reducing it.

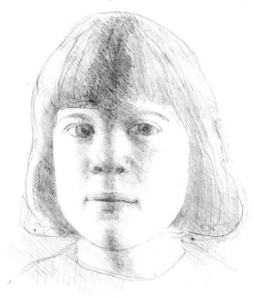

Light from both sides emphasizes the fullness of the jaw line.

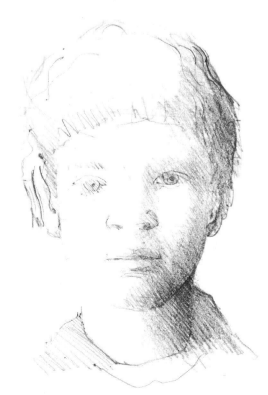

A very useful light, slightly from above and to one side just catching the cheek of the dark side. Notice how the dark area has been blocked in without drawing anything in detail.

17

Choosing a pose

Choose a pose that is both characteristic and animated. If your sitter is slumped in a chair, looking straight ahead and with no turn of the head on the shoulders, your drawing will be dull.

Consider the position of the head and neck in relation to the shoulders. Look at the simple form of the neck and realize that it is cylindrical. See how the contour of the shoulder flows from the neck, and notice the spaces formed by the line of jaw and shoulder. Think of the head and neck as one continuous form. Always relate the position of the centre of the base of the neck to the chin.

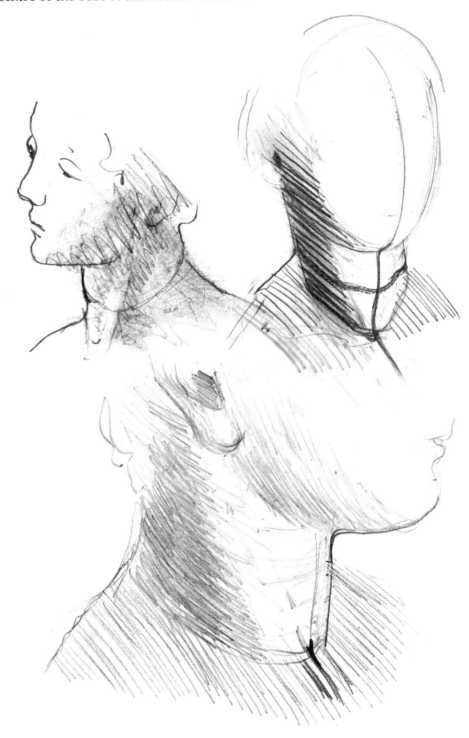

The way the eyes are directed in relation to the turn of the head and shoulders will add considerably to the animation of the pose.

Look at these different poses of the same person. Note the turn of the head; the shoulder line in relation to the chin or cheek and the direction of the eyes; and the slope of the shoulders and thrust of the chin. Notice whether the eyes are looking in advance of the turned head or in a contrary direction.

Pose your sitter in different ways until you find the most characteristic pose. Avoid a pose that will be difficult to keep for any length of time. In any case, be sure to let your sitter rest at regular intervals.

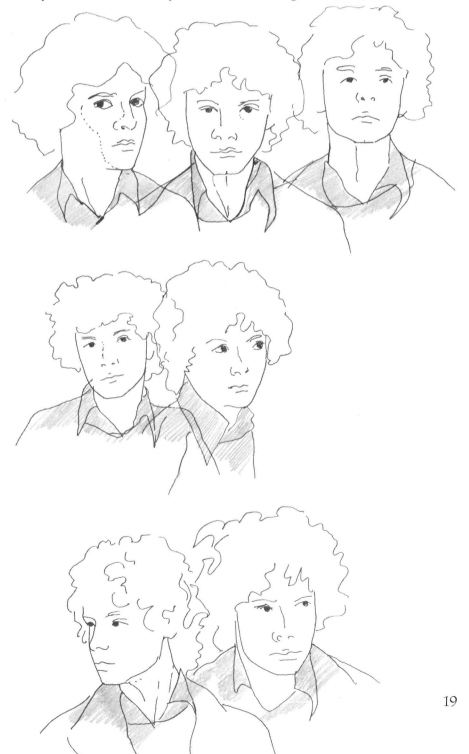

Profile

You may decide that the most characteristic aspect of your sitter is the profile.

To achieve a likeness in profile, you will need very accurate observation and skilled control of your pencil.

The slightest variation in the thickness and emphasis of line will change the appearance. Avoid simply following the contour without first understanding the complete shape.

Use your pencil lightly, and gradually build up the contour and forms. In this way you will avoid a heavy, confused line.

Study a head turning into the profile and note the changing space between the cheekbone and eye and the contour of the nose.

Remember that a profile is a three-dimensional form. Look for the points nearest to you (cheekbone and ear) and follow with your pencil the forms of the jaw. The sketch below shows how the roundness of this contour is formed. Watch for relative positions on a vertical (eye and mouth) and the direction of the line from forehead to nose and nose to chin.

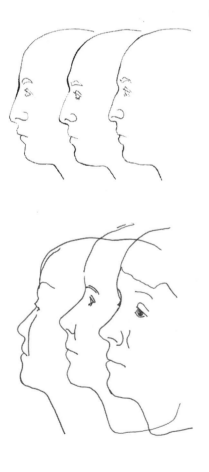

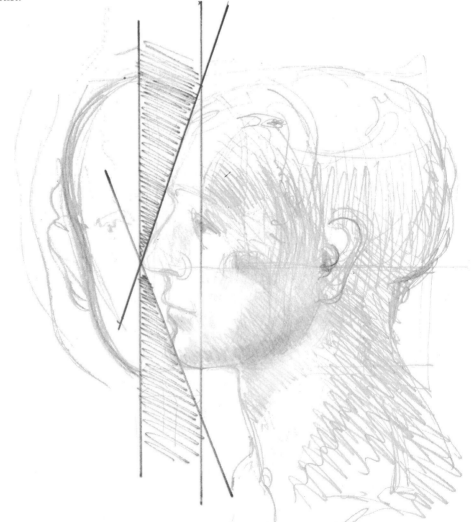

Pin up a square of dark card behind the sitter, large enough to cover the area of the head. Adjust your position so that the vertical edge of the card just touches the tip of the nose. Look for the background shapes, the proportions, and begin to feel for the form of the cheek.

Build up the contour with a gentle broken line. Establish relative vertical and horizontal points.

Concentrate on the main dark areas, looking all the time for shapes. Adjust your position if necessary to keep the original pose (in this pose you can just see the lid of the far eye).

Soften or erase unwanted lines by pressing with a kneaded eraser.

Vary the quality of the line. Notice the shape of the eye and how it is foreshortened when seen from the side.

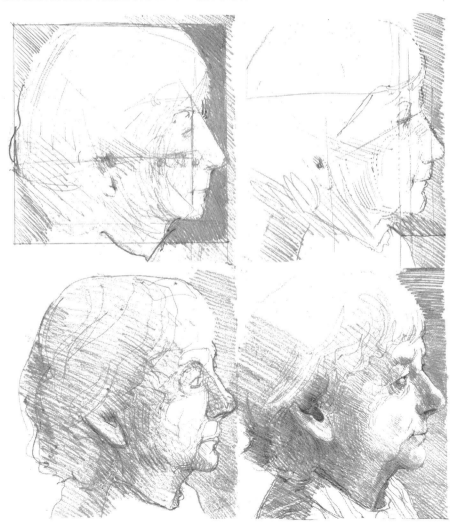

Three-quarter and full face

Note what happens to the perspective of the front of this box when it is turned to the side:

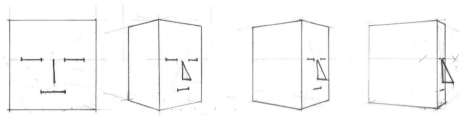

The same changes take place when a head turns from profile through three-quarters to full face. The drawing below illustrates these changes, using a very simple line and a contrasting background. Note particularly how the distance between the outside corners of the eyes becomes longer and the distance from the corner of the eye to the ear becomes shorter.

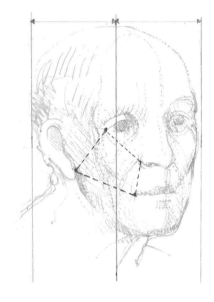

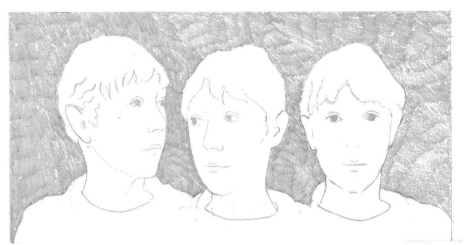

Begin the three-quarter view by fixing the position of the nearer eye. The drawing on the left shows how it falls half way across the width of the head. (See page 6 to help you establish relative distances.)

Make a study of the relative positions of the four points surrounding the cheek bone. Discover how the shape of the cheek bone and jaw form the contour. Feel the forms with a gentle line. Note the position of the chin in relation to the neck.

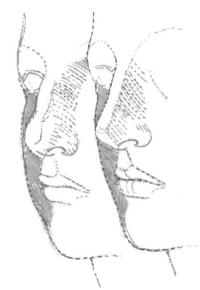

Understanding the contour of the three-quarter view plays an important part in portrait drawing.

Avoid a heavy and unvaried line as it will flatten the form. Observe carefully the shaded areas here. Look at the shape of the foreshortened mouth and note how a variation in the contour changes the appearance. Notice the difference between the form and contour of the two noses.

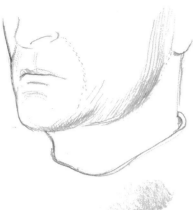

Study also how the jaw line is formed. Think of the rounded forms flowing into the forms of the neck. Don't make the mistake of drawing the jaw with a solid hard line.

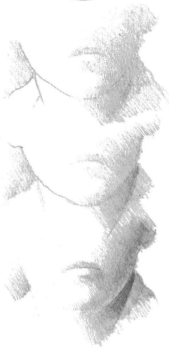

In a full face drawing the jaw line must be treated as the contour of the three-quarter view. Again, avoid a heavy, unvaried line. You can usually see some reflected light on the jaw. Never exaggerate this— darken the whole area, then increase the depth of tone surrounding the jaw line until it appears to lighten.

The right-hand pose below has more life than the one on the left. The head is turned away and the contrasting tone of the background heightens this tension.

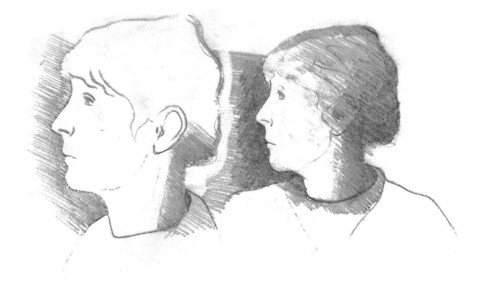

Features: eyes

You have seen the importance of understanding the complete shape of the head and finding its characteristic variations. Now you need to fit the features within the shape. The most dangerous trap in portraiture is to suppose that a likeness depends on the features alone. It is the shapes between the features and how these and the features fit within the head that create the likeness.

To position the eyes correctly, look for the important relative distances (a). (See also page 6.)

(a)

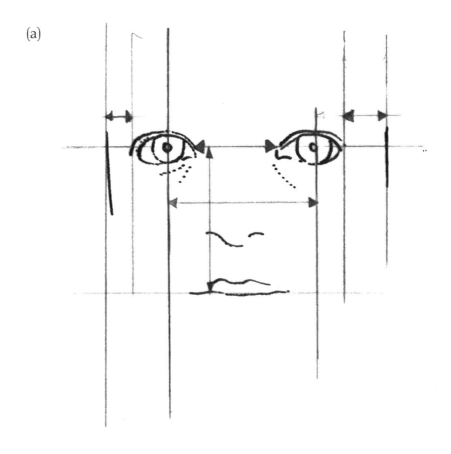

(b)

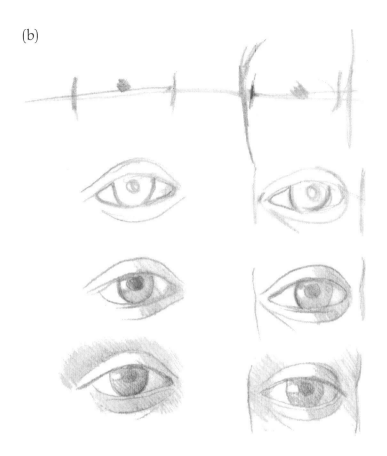

(c)

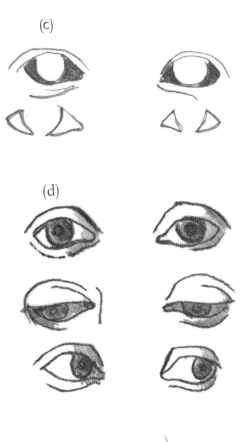

(d)

(e)

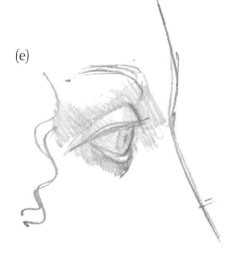

Watch for how much of the eyelid is visible (b) and the different shapes of the white areas (c). Indicate the rounded form of the eye by darkening the side away from the light. Then build up the variations of tone surrounding the eye. It is very important to indicate the overall tone of the iris and the character of its outline.

Notice how the eyes change shape according to the direction of the gaze (d).

The fleshiness of the skin surrounding the eye, and the angle of the iris, both give character to the eye (e).

As you are drawing the eyes, keep checking relative distances and remember to give equal attention to the surrounding forms of cheek, brow and nose. Note the shadow cast on the iris by the eyelid (f).

(f)

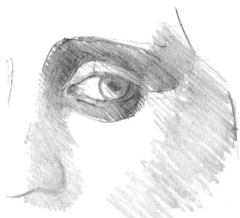

Features: mouth

The mouth should be seen as part of the surrounding area and the chin. Study the form of the mouth and chin in profile. Never make too definite a line where the lip colour changes to skin colour. It is easy to over-emphasize this tonal change. Think constantly of the form flowing from the lips to the surrounding areas.

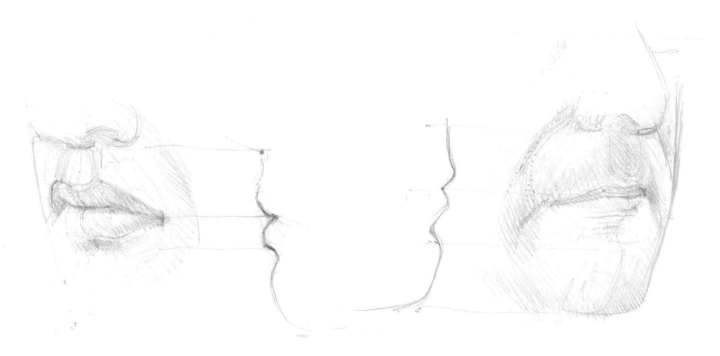

Feel for the forms with your pencil. Determine the direction of the mouth and its size in relation to the nose.

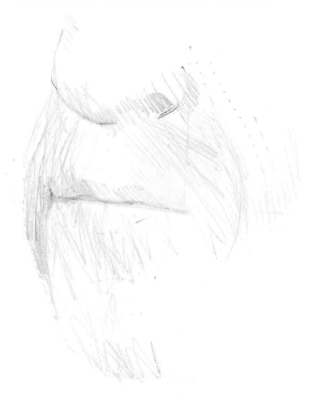

Draw round the lightest areas to develop the form of the lower lip and chin. Avoid using a hard line to delineate the lips and the division between them.

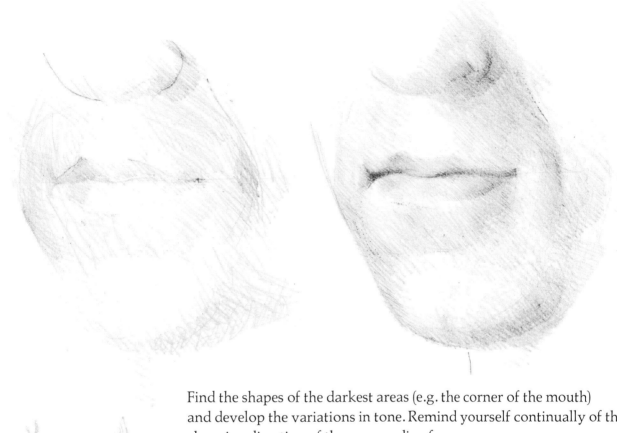

Find the shapes of the darkest areas (e.g. the corner of the mouth) and develop the variations in tone. Remind yourself continually of the changing direction of the surrounding forms.

Look for variation in the line along the centre of the mouth. The quality of this line shows the character of the mouth.

The form of the lips and the area between the top lip and the nose are important. Always note the characteristic shape and never exaggerate the variations of tone within it.

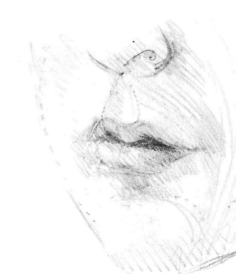

Features: nose

This drawing illustrates how the forms of the features fit into the forms of the head.

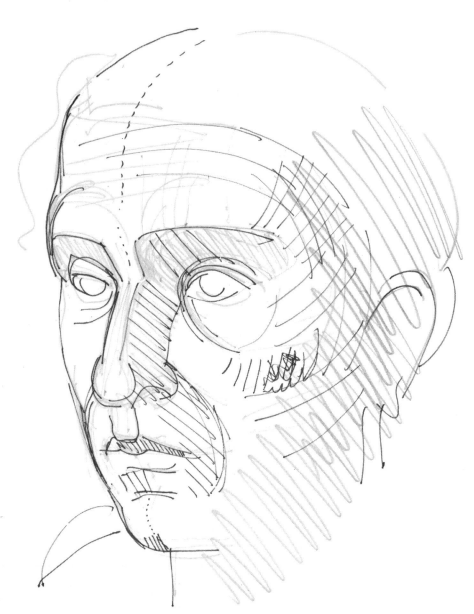

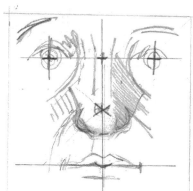

Remember some basic proportions — eye centre to eye centre, bridge of nose to mouth, tip of nose to bridge and to mouth — and how they relate to the whole head.

Exercises

Here are some simple exercises to encourage you to see one thing in relation to another.

1. See how well you can draw the relative positions of a random collection of matches.
2. Work out the overall shape of the group.

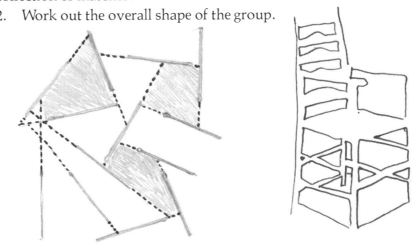

3. Continue the direction of each match and see how many shapes can be made by the intersection of these lines.
4. Draw the shapes of the spaces you can see through an object such as a chair.
5. Draw a group of objects with a continuous line, making your eye move rapidly from side to side as you draw.
6. Practise rapid drawing without taking your eye off the subject.

Hair

Never think of the hair as individual strands. Think of the total shape and how the contour follows the main changes in direction of the skull. Look for the quality of the hair and vary your use of the pencil accordingly.

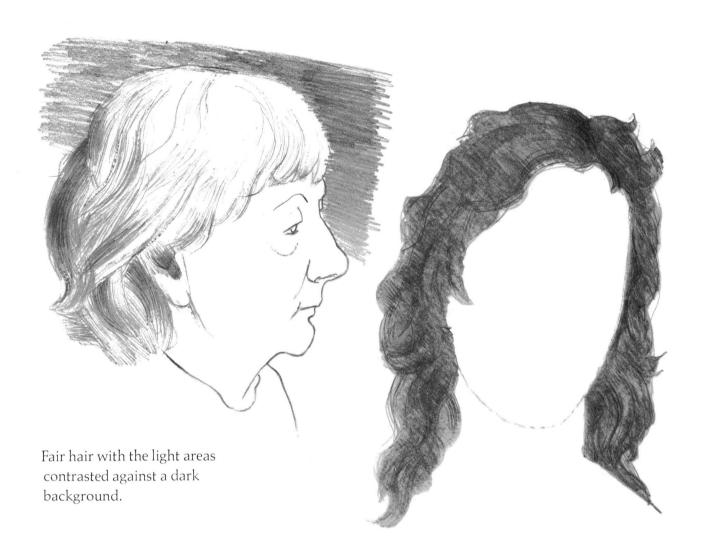

Fair hair with the light areas contrasted against a dark background.

The solid mass of dark hair. Hard lines on the contour will spoil the effect of softness.

Block in the general tone of the hair. Accentuate the light areas by increasing the depth of the dark areas. Finally use a kneaded eraser to draw the few highlights.

Note the way different types of hair fall into smaller shapes. These shapes will have light and dark areas.

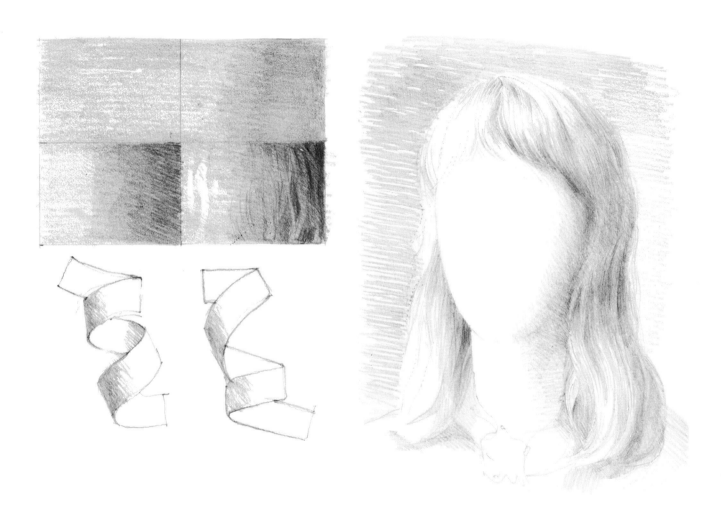

Vary the line to emphasize the quality of the hair.

Expression

Expression is caused by fleeting changes in the face, so never attempt to draw an expression. Instead, as the drawing progresses, notice the characteristic ways in which small changes take place when your sitter is talking or thinking, and when you consider that your drawing is nearly completed make some final adjustments to the features.

Note the different treatment of the lower eye lid and the mouth in these three drawings.

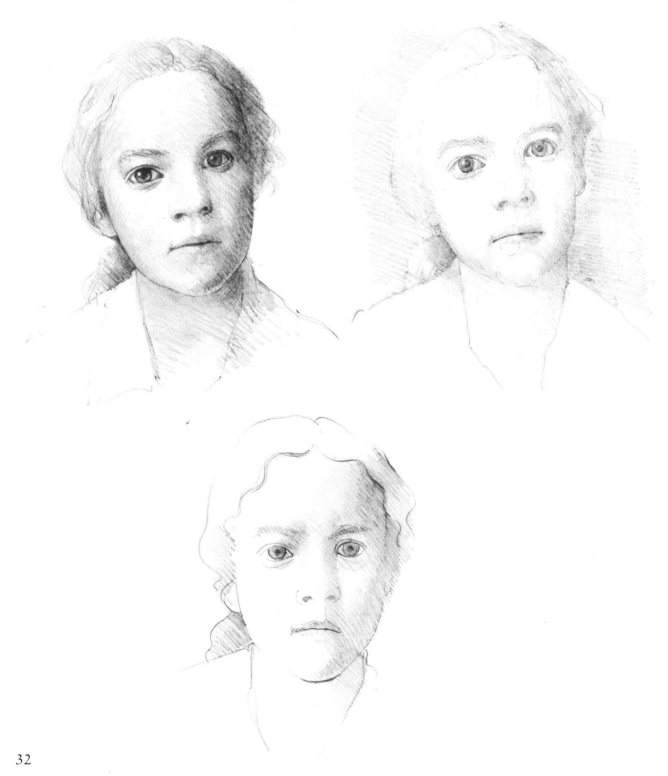

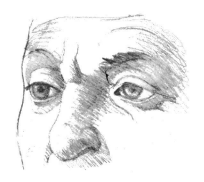

Look for any changes in the surface forms of the brow (left, above), the sparkle in the eye (left, below) and the related expression of the liquid eye and slightly open mouth (below).

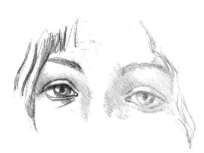

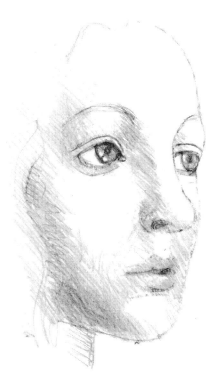

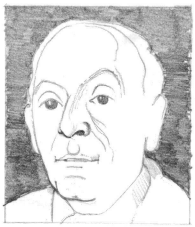

When a smile begins the contour of the cheek changes and the lower eyelid is pushed up.

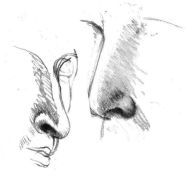

Watch the movement of the eyebrows; you may need to emphasize the nostrils and the surrounding forms.

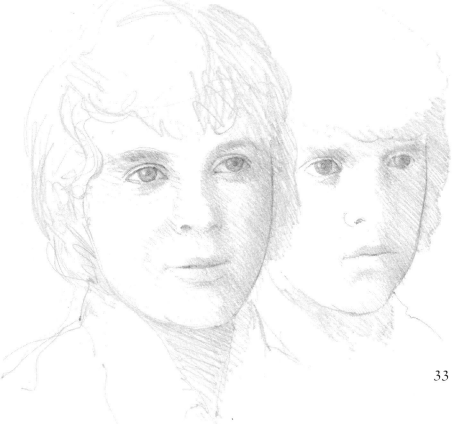

Notice the shape of the dark area of the nostril.

Self portrait

The main problem with a self portrait is that you cannot see your reflection and the drawing simultaneously, so you have to remember what you see.

With your head moving continuously from drawing to reflection it is difficult to keep re-establishing the same pose.

Choose a pose, then note the position of the iris, the distance from the corner of the mouth to the point where the neckline and cheek line join, and the relative distances A and B. These are foreshortened planes and the tendency is to exaggerate them and so make the head too wide.

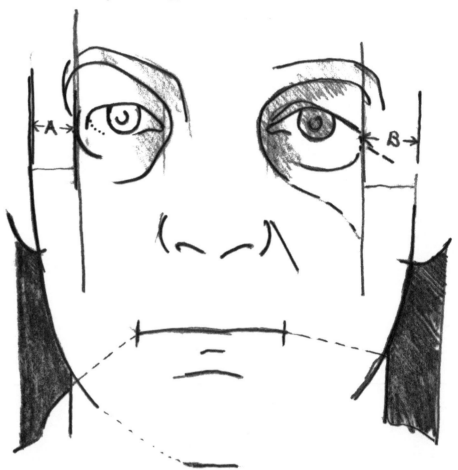

Mark your face with eight dots and note their relative positions when you have fixed your pose. Imagine lines joining the dots and the shapes that these lines would make. The drawings opposite show how this shape will change as the position of the head changes. Note the very important direction of the line between the dot on the cheek and the ear lobe; and the relative position of nose and ear depending on the tilt of the head.

Every time you look at your reflection, check and re-establish these points of reference.

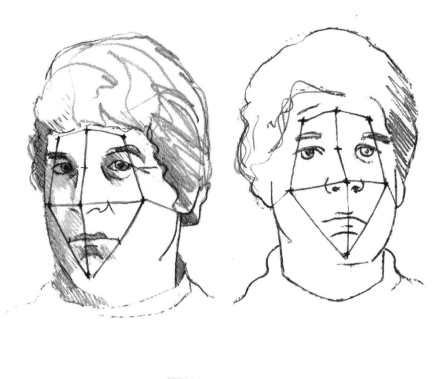

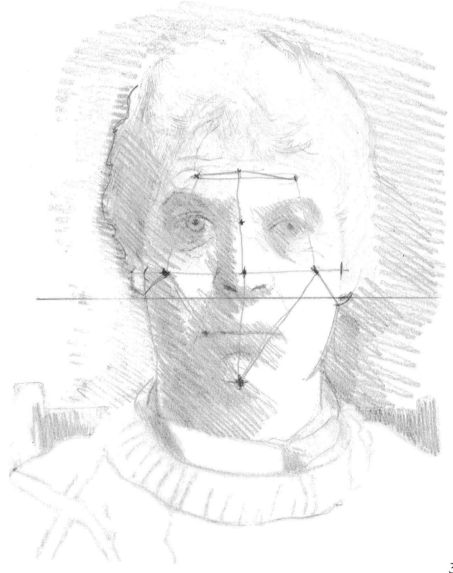

Pay particular attention to the shapes surrounding the eyes and the shapes of the whites of the eyes.

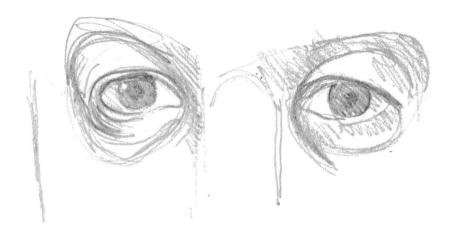

The easiest trap to fall into is to concentrate only on small areas.

Refer back to the pages on features, hair and the use of the pencil, and see how all these points are tackled in the finished drawing opposite.

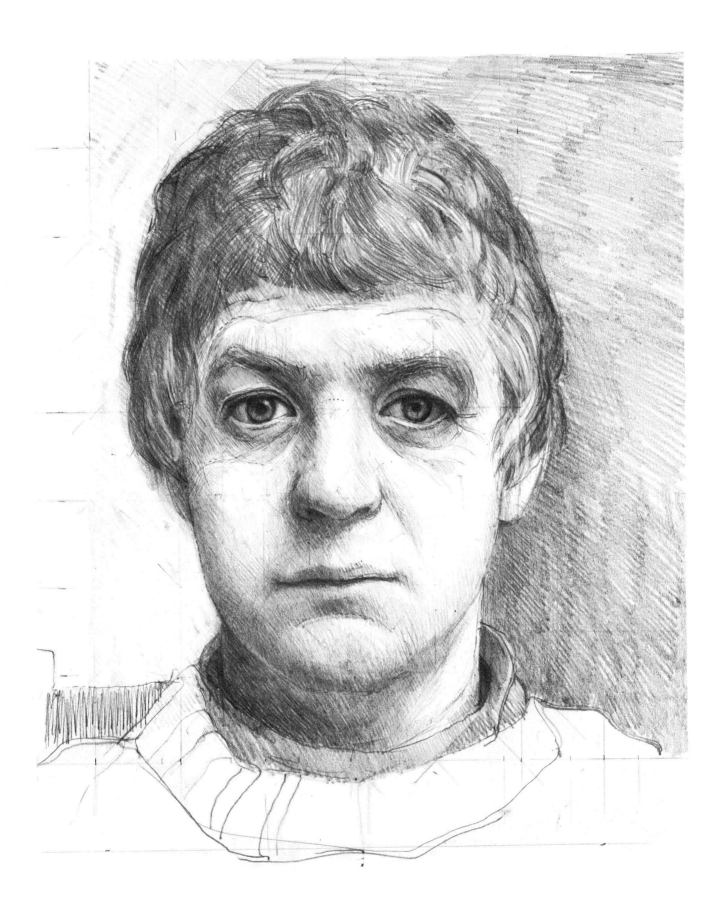

Copying and other aids

Remember that a good portrait likeness depends on accurate drawing. You must see and understand the whole form and all the relative positions of the features.

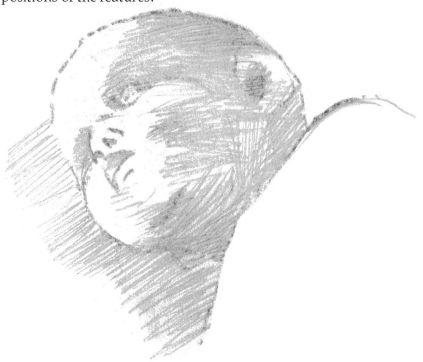

Practise your technique of seeing and discovering by drawing from a bust. Draw it from as many unusual angles as possible; use unusual lighting and different media.

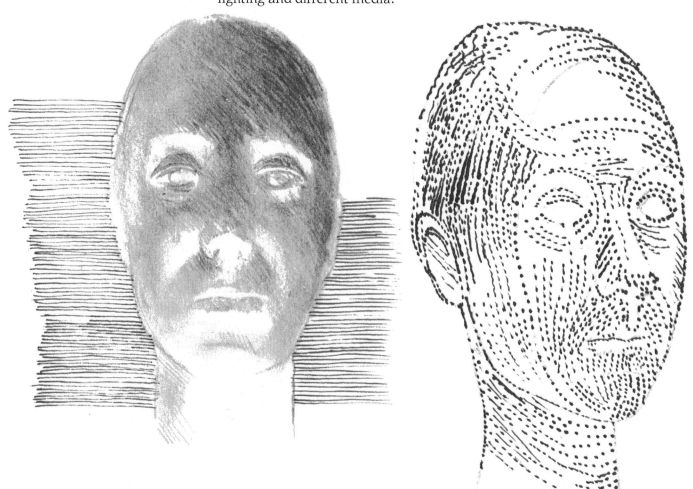

You can learn a lot by copying drawings by the great masters. Ask yourself what they have selected to draw and what they have left out.

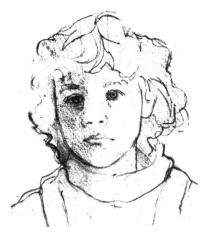

Do not overwork a drawing. A finished drawing does not have to describe every aspect in great detail.

Try copying on to glass, to help you understand basic shapes and proportions. Place the glass between yourself and the sitter. Trace the main outlines and then the positions of mouth, eyes, etc. Use a fine felt pen. Keep your head very still and draw with one eye closed. It will take a lot of practice. Draw a grid over the drawing and then transfer it on to paper.

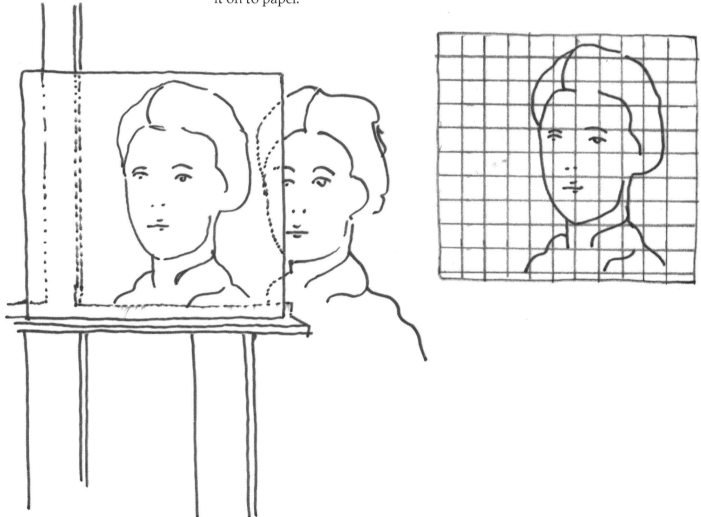

Hold up a stick in front of your subject with your arm outstretched.
Make two marks to correspond with the position of the eye and mouth.
Make two or three more marks on the stick at equal intervals, hold up
the stick again and note where these marks fall on the head. Then turn
your hand through 90° and compare these distances on the horizontal.

Make similar marks or knots on a weighted thread (plumb line). Move
your arm from side to side, noting all the relative points on the vertical.

(Both these operations must be done with one eye closed.)

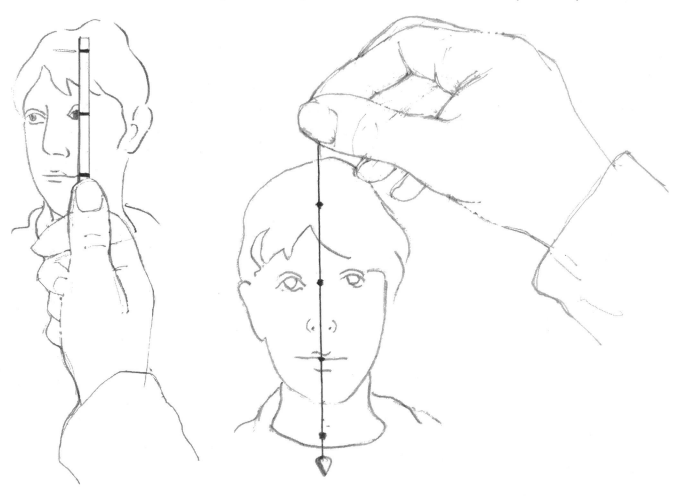

Racial types

Variations in the shape of the skull cause different types of face. Before you begin a drawing—say of an African—analyse the shape of the skull and try to imagine its profile. Use the plumb line to relate points on the vertical

See how the shape relates to a square.

There are enormous variations within each racial type.

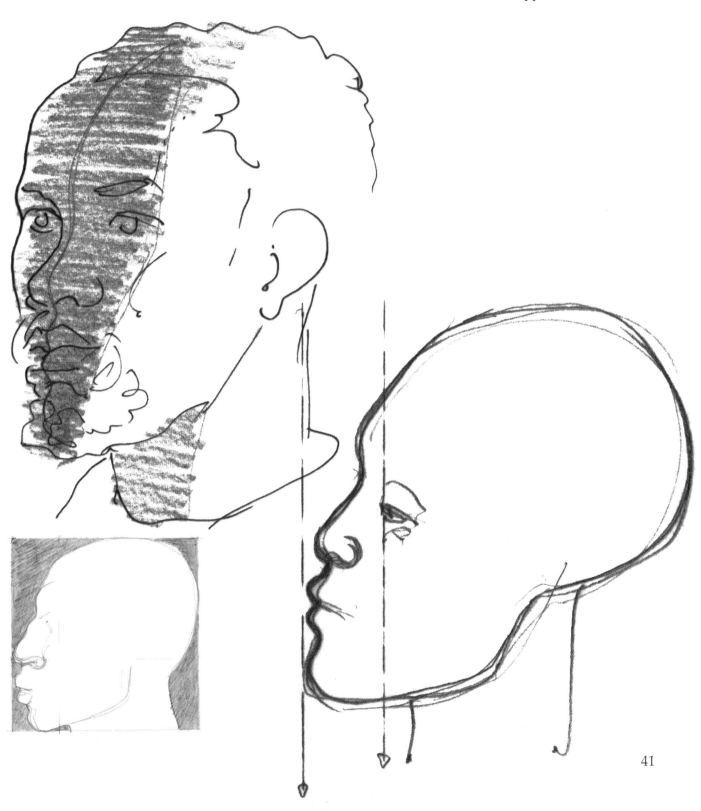

This European has a wide face caused by the large difference between the width of the cheek bones and the width of the skull. Ask yourself questions: for example, are the eyes unusually close together? Is the skull unusually wide?

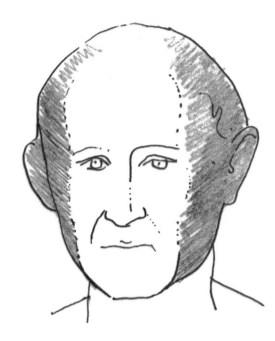

An Oriental head is generally characterised by full cheek bones. This will influence the shape of the eye.

Be careful not to exaggerate the differences or the portrait will become a caricature.

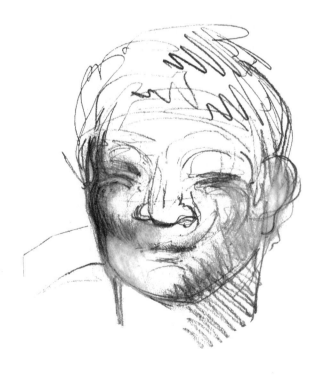

Beards

The main point to remember is to draw the complete shape and then block in the general tone. Whenever possible, see how the beard follows the forms of the jaw, chin and upper lip.

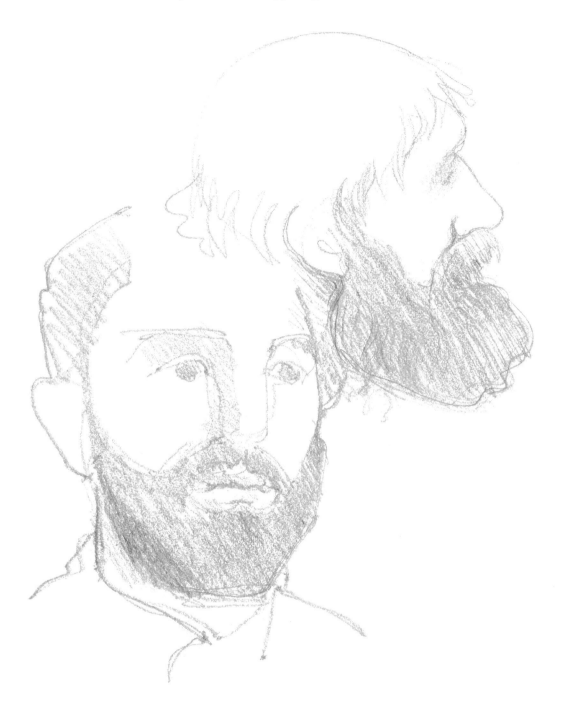

Spectacles

Light falling directly on the front of the face of a person wearing spectacles will be reflected in the glass, making it difficult to see the shape of the eyes. Have the light coming from the side or from behind the head. You can use the shape of the spectacles to help you see the form of the head.

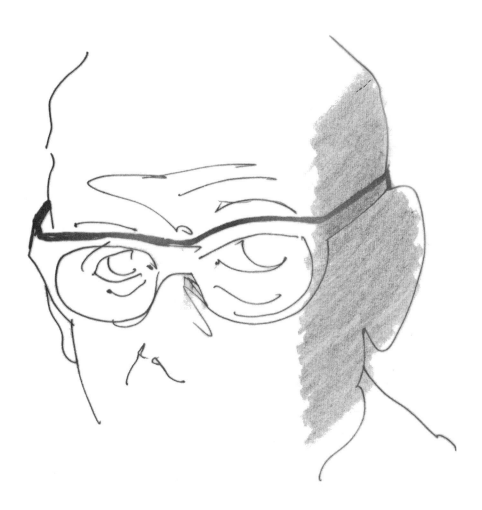

Group portraits

Make separate studies of each member of the group (pose, light, shape of head and shoulders), then make tracings of each drawing. Shift these tracings around until you have arranged a satisfactory composition.

The drawing below shows three views of the same head. The composition was established as described above. Note the line curving through each mouth and continuing through to the two outside shoulders. There is a similar curve through the eyes. These two curved lines form the basis of the composition.

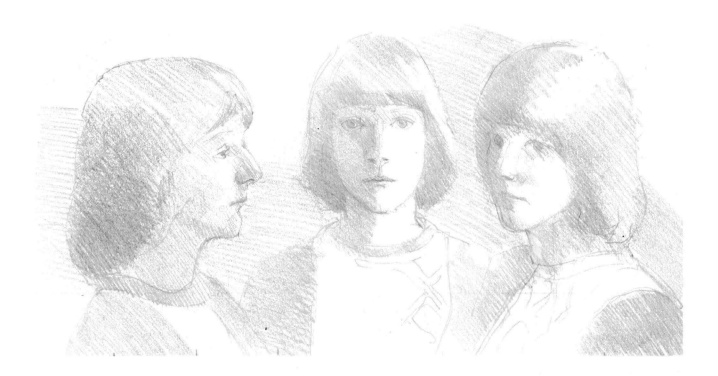

A portrait step by step

Remember to let your pencil describe what you have seen and understood.

1. Feel for the shapes of the light and dark areas.

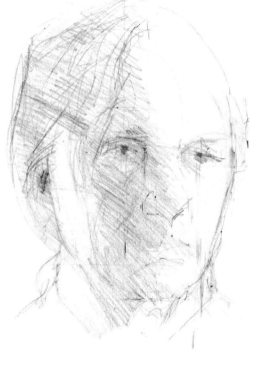

2. Constantly re-establish proportions (e.g. the position of the eye nearest to you in relation to the width of the head). Let your pencil flow from shape to shape and from point to point. Follow and continue the directions of lines (e.g. from the eye towards the ear, from the ear to the jaw and, in this case, from neck to brooch).

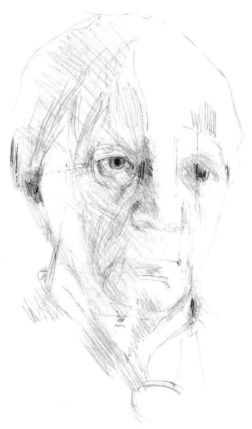

3. Gradually build up the tones, continually checking shapes (e.g. the light area of the upper lip) and relative points on a horizontal and vertical line (e.g. eye to corner of mouth to line of neck).

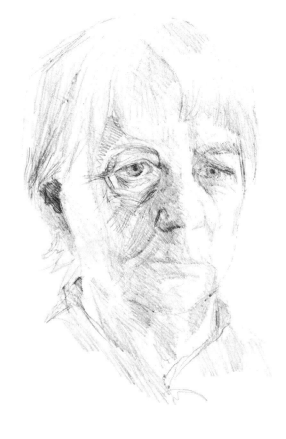

4. Be careful not to overwork the drawing. A simple line drawn with understanding has more life than an overworked line that is only half-understood.

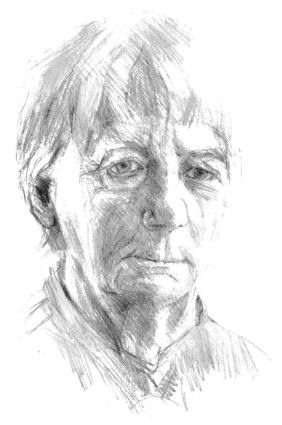

The finished drawing is shown on the next page.

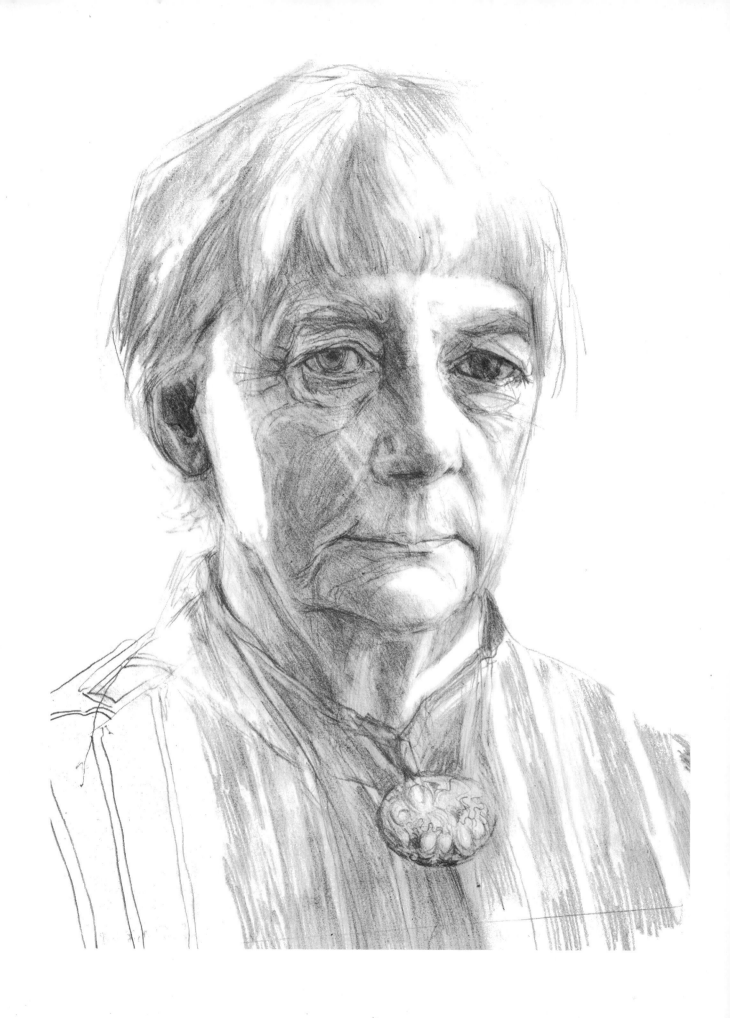